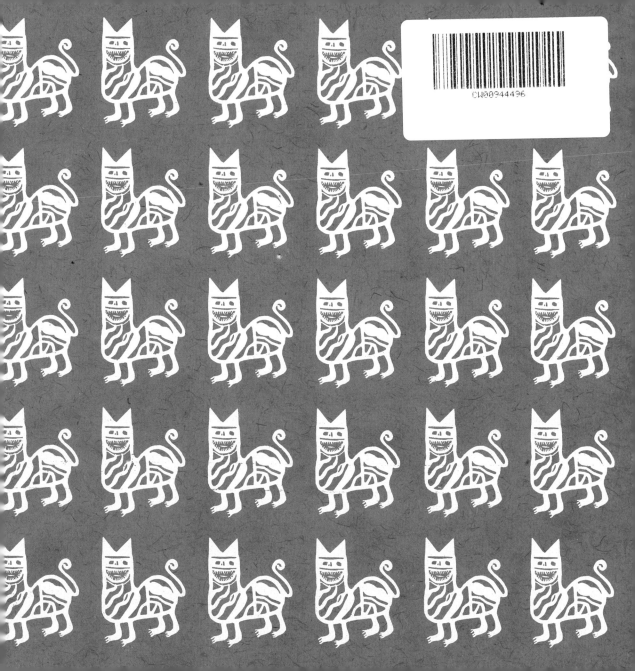

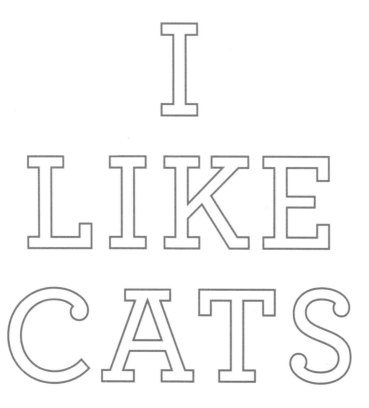

I LIKE CATS

Anushka Ravishankar & various artists

Sunny cats

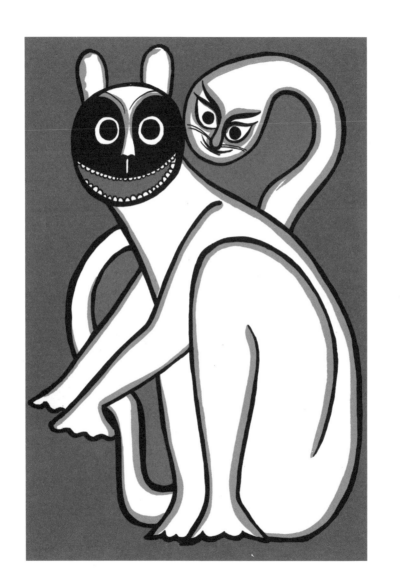

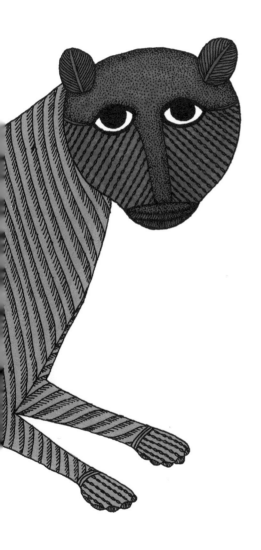

Sad cats

Greedy cats

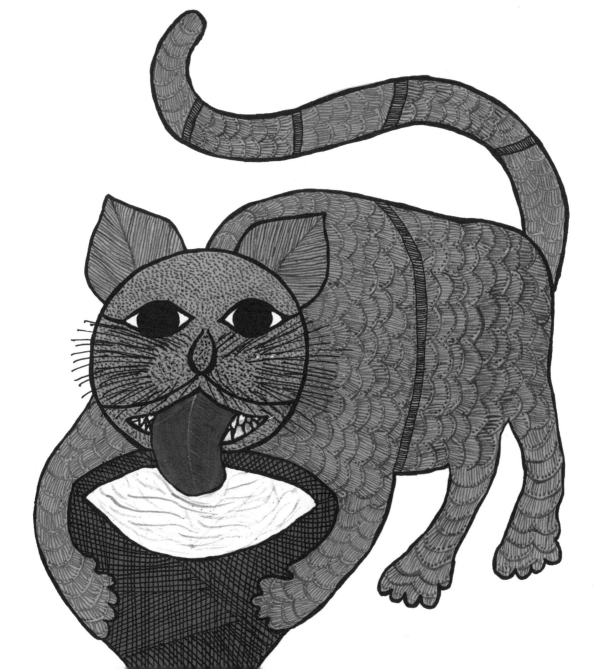

BAD cats

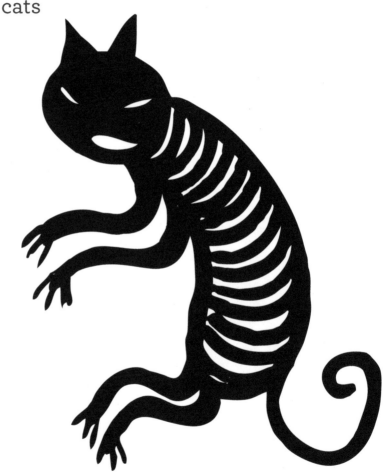

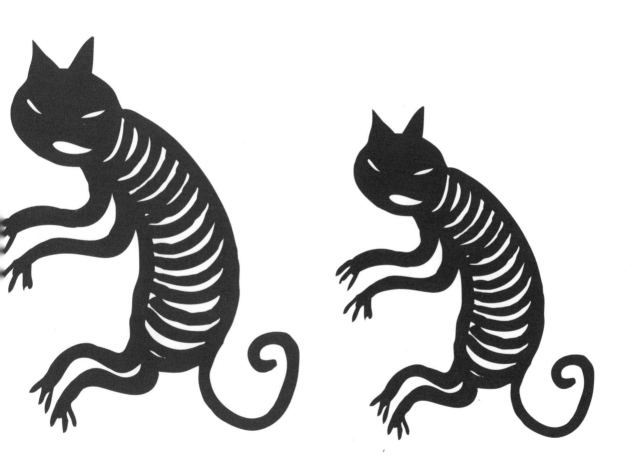

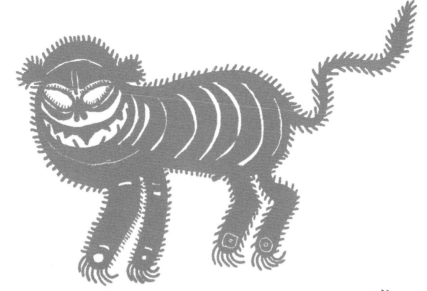
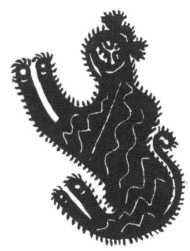

Grinning cats

Cats with scowls

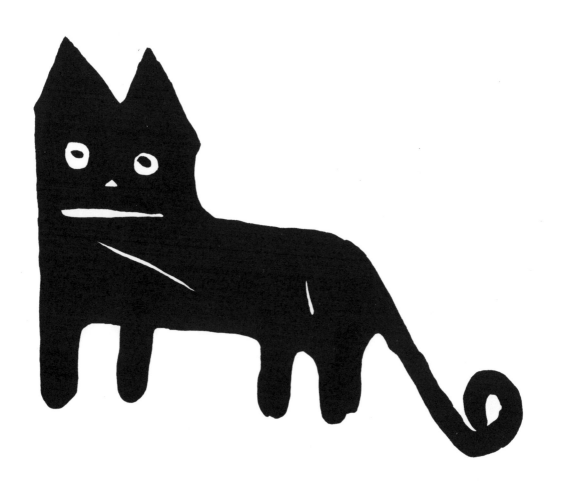

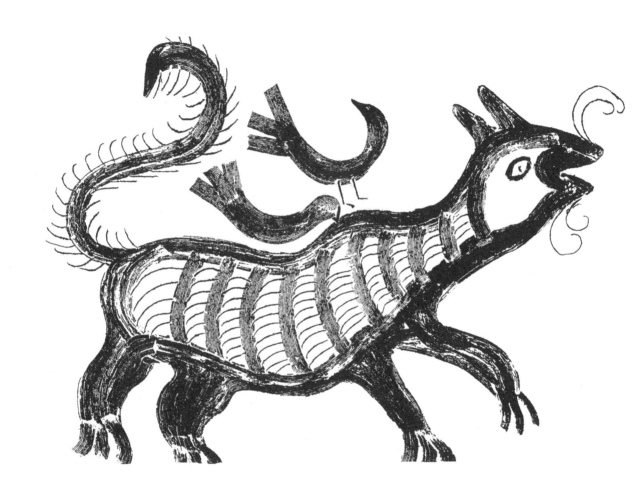

Chinless cats

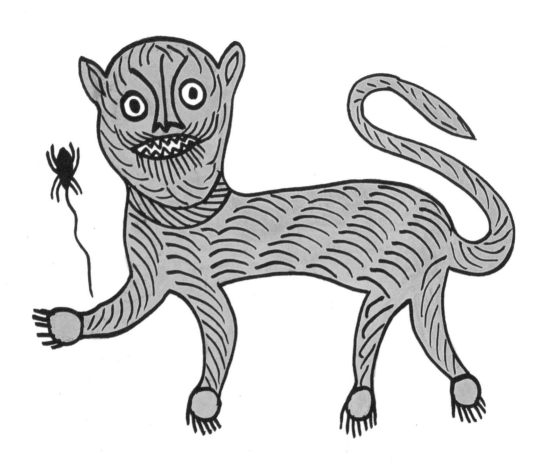

Cats with jowls

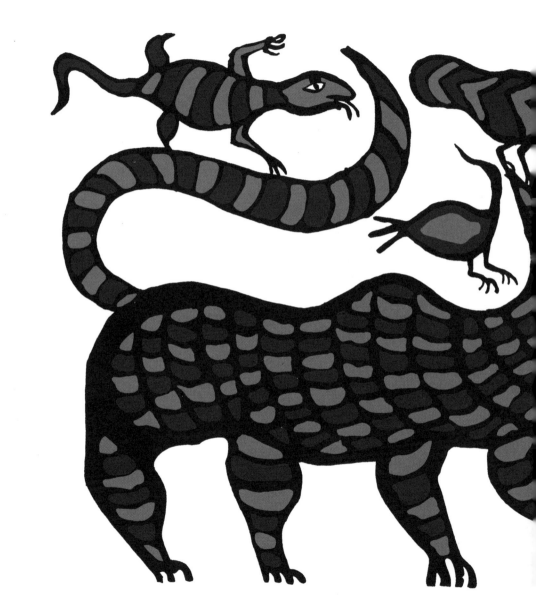

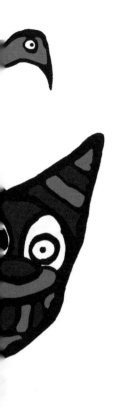

Smug cats

Worried **cats**

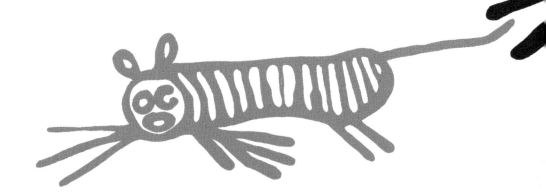

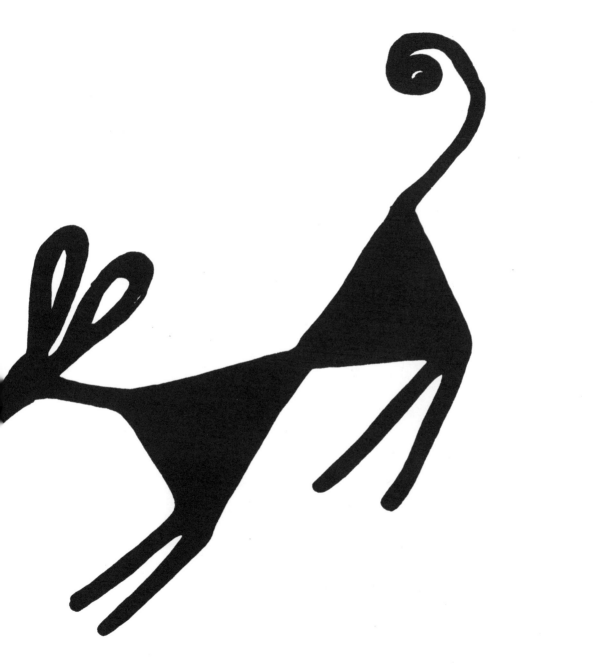

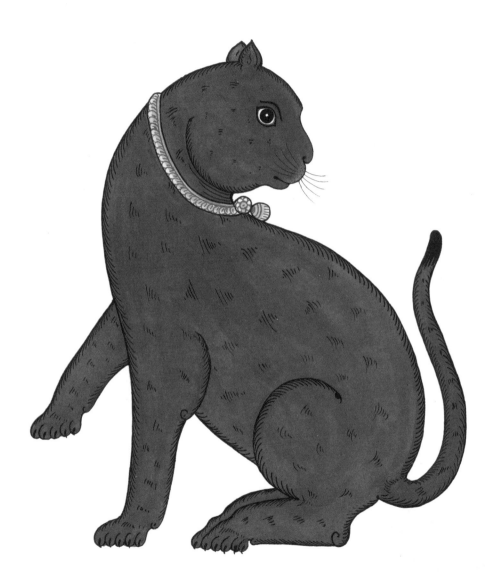

S l o w cats

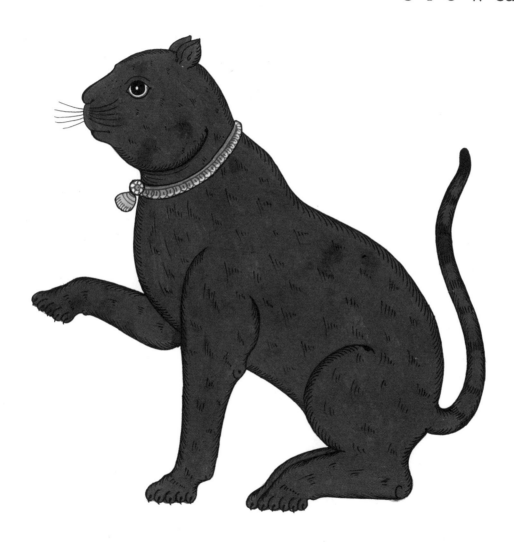

Hurried cats

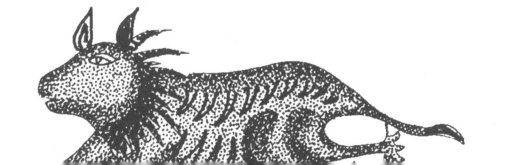

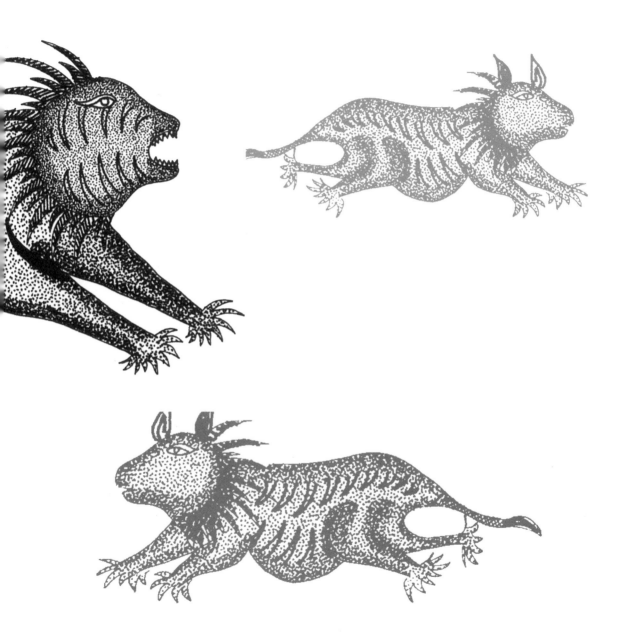

Thin cats

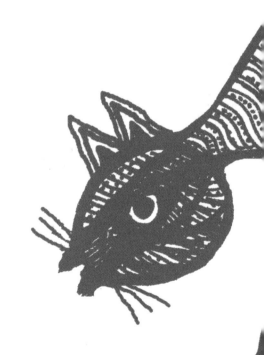

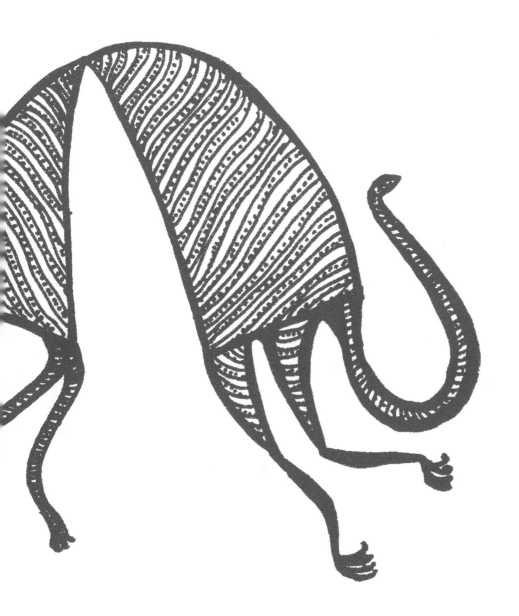

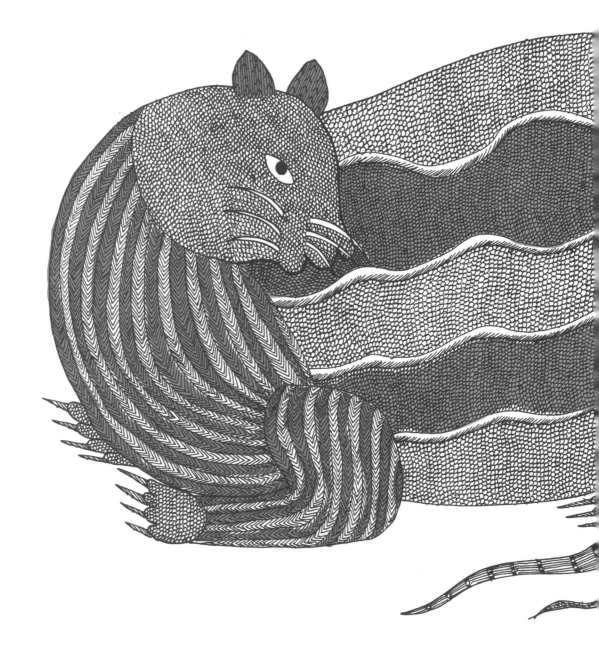

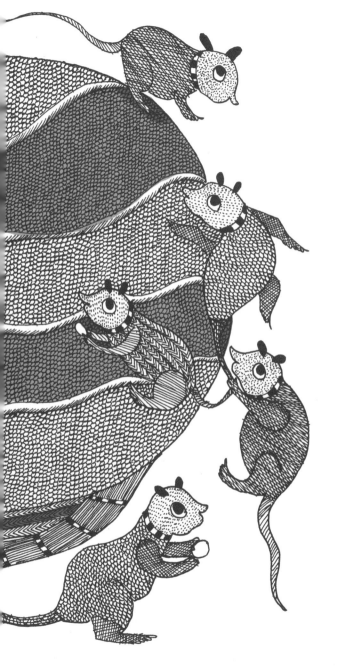

Fat _{cats}

Saintly cats

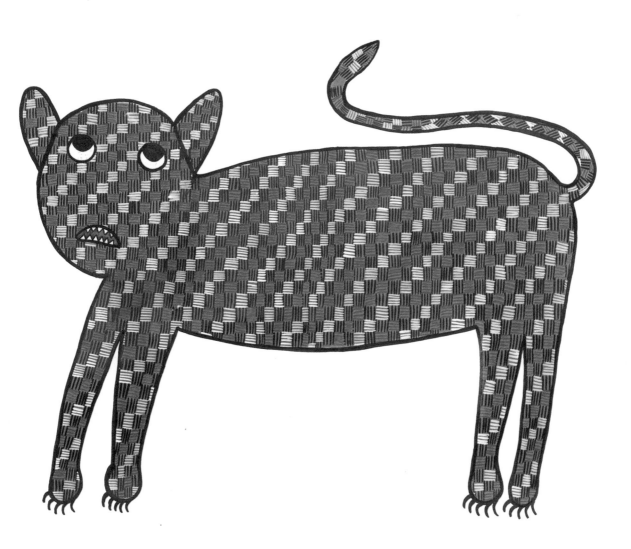

Brat _{cats}

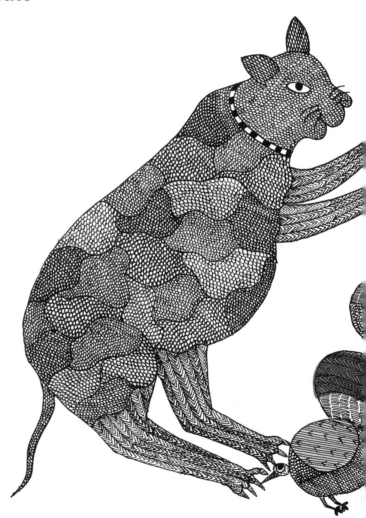

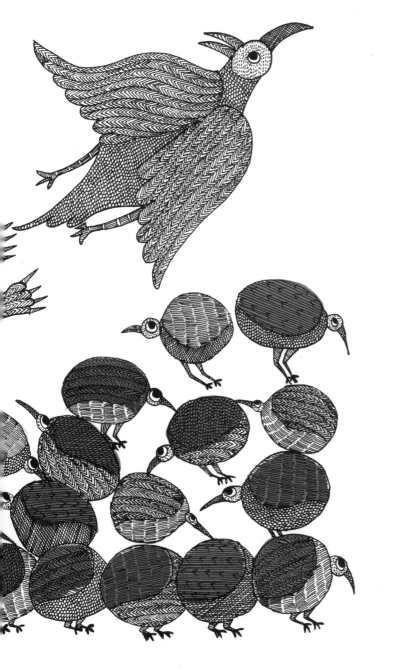

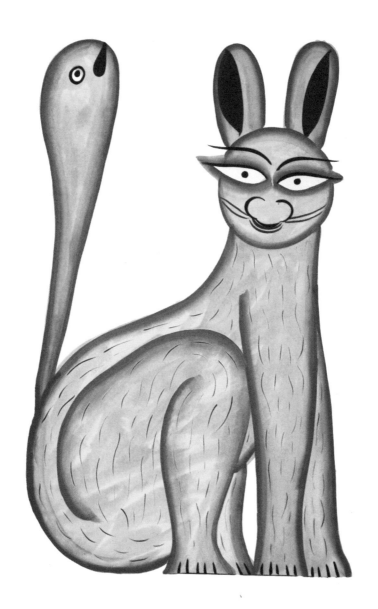

Single cats

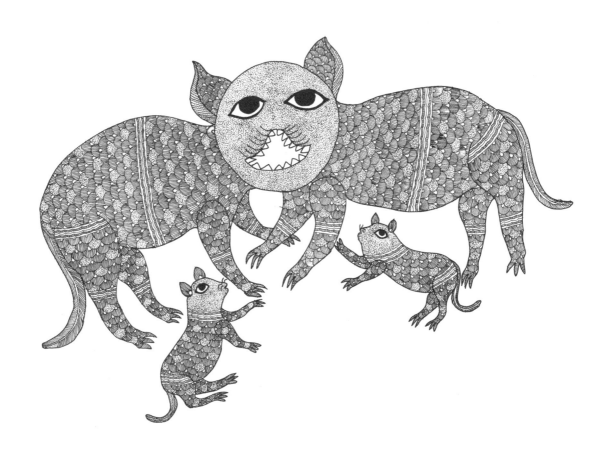

Paired cats

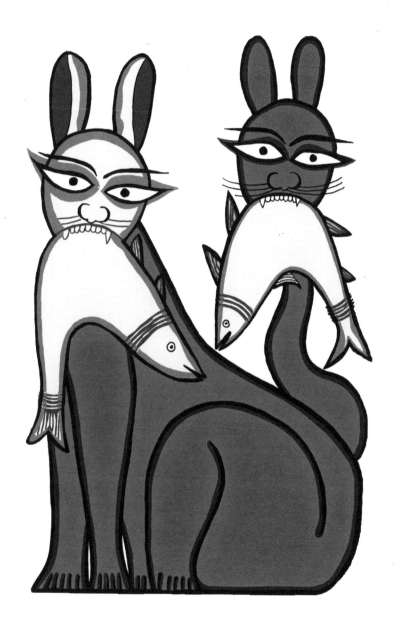

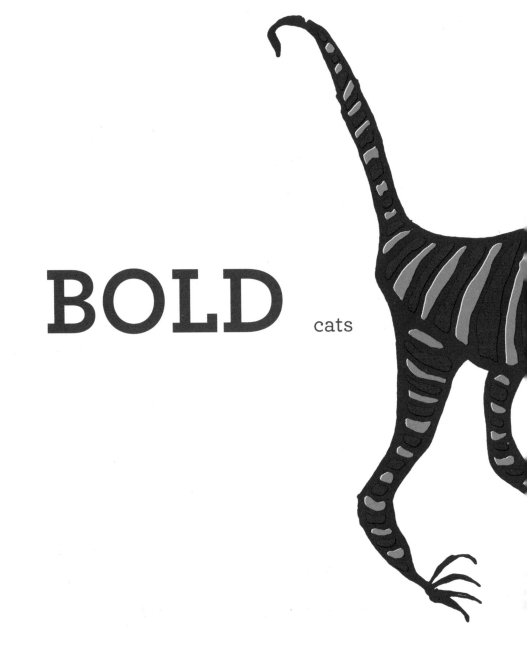

BOLD cats

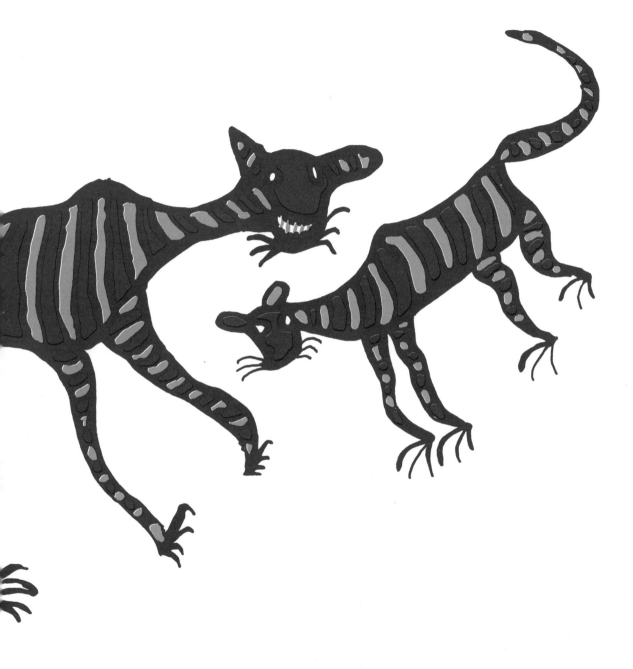

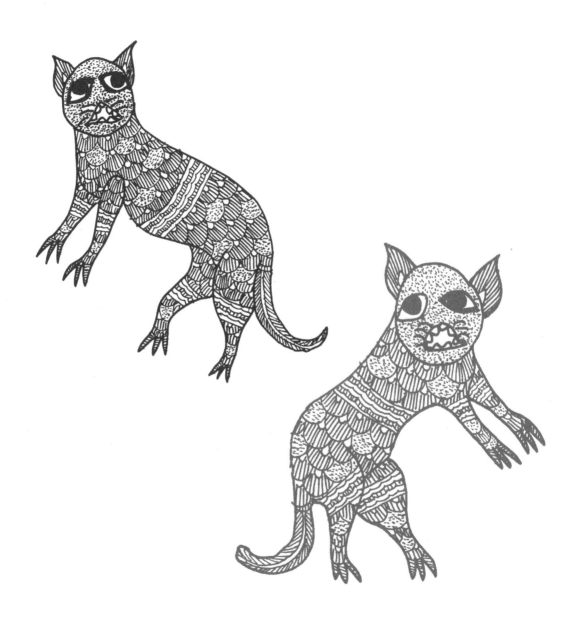

scared cats

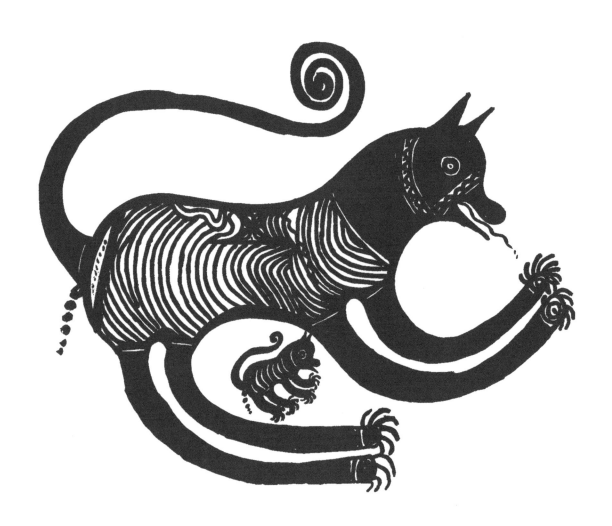

Striped cats

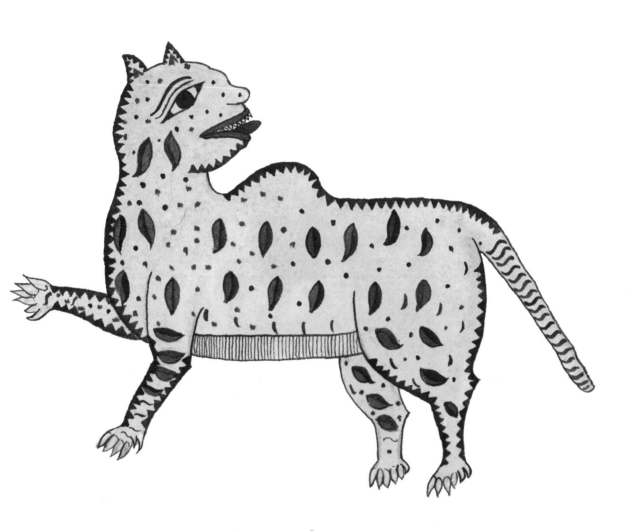

Cats with spots

Dazed cats

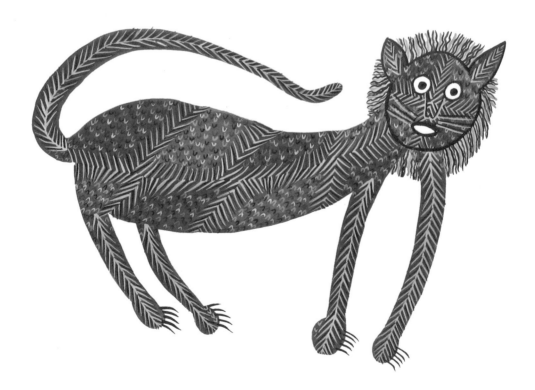

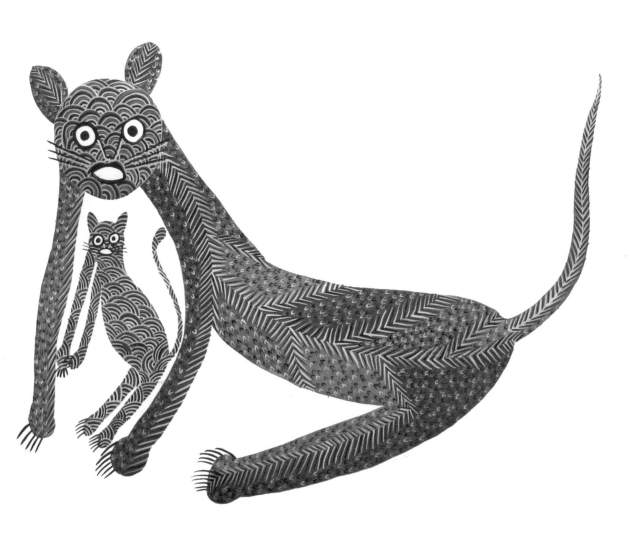

Cats with thoughts

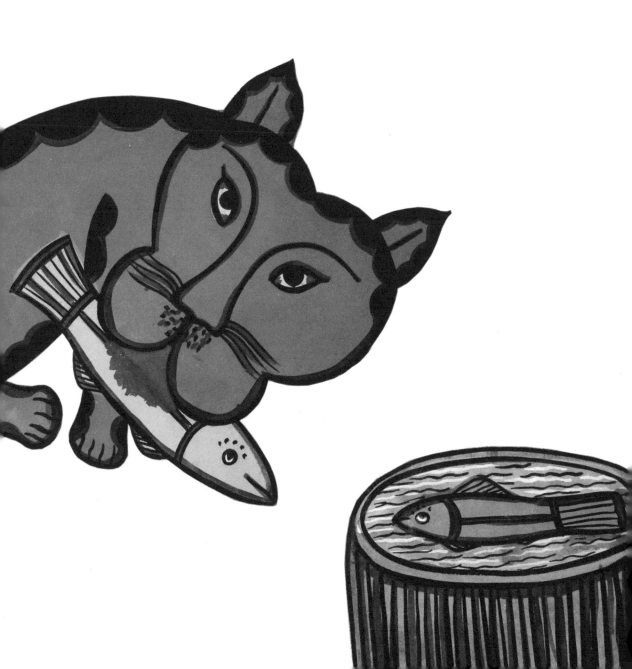

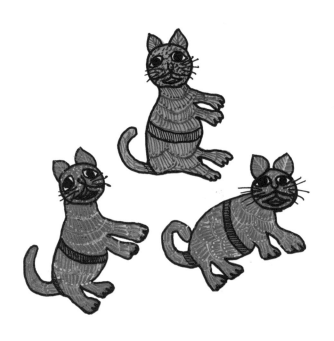

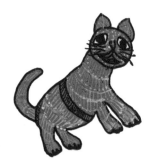

I LIKE cats.

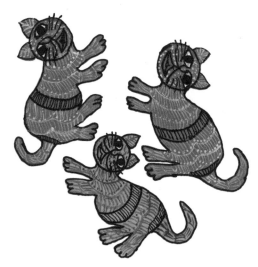

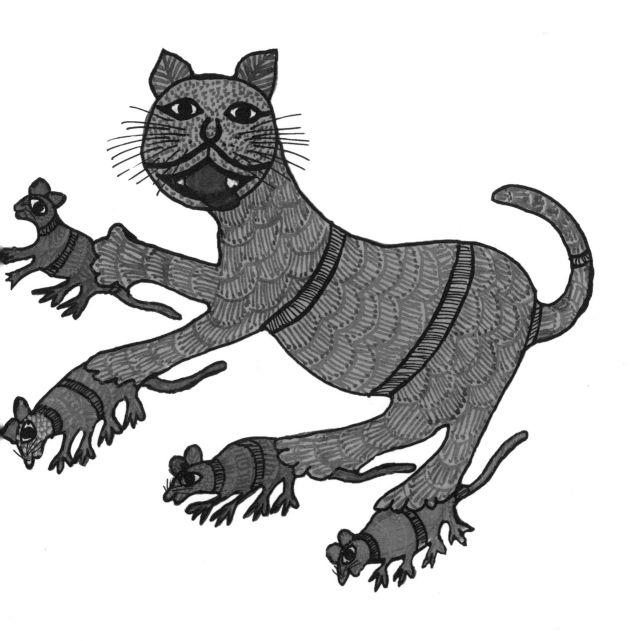

Front and back cover
Art: Patua scroll painting
Area: West Bengal
Artist: Swarna Chitrakar

"Sunny cat"
Art: Patua scroll painting
Area: West Bengal
Artist: Swarna Chitrakar

"Sad cat"
Art: Gond tribal
Area: Madhya Pradesh
Artist: Bhajju Shyam

"Greedy cat"
Art: Gond tribal
Area: Madhya Pradesh
Artist: Durga Bai

"Bad cats"
Art: Meena tribal
Area: Rajasthan
Artist: Unknown

"Grinning cats"
Art: Meena tribal
Area: Rajasthan
Artist: Unknown

"Cats with scowls"
Art: Meena tribal
Area: Rajasthan
Artist: Unknown

"Chinless cats"
Art: Sohrai
Area: Jharkhand
Artist: Putli Ganju

"Cats with jowls"
Art: Pithora
Area: Rajasthan/Gujarat
Artist: Chelia Hamir

"Smug cats"
Art: Sohrai
Area: Jharkhand
Artist: Putli Ganju

"Worried cats"
Art: Warli
Area: Maharashtra
Artist: Balu Ladkya Domada

"Slow cats"
Art: Patachitra
Area: Orissa
Artist: Radhashyam Raut

"Hurried cats"
Art: Gond tribal
Area: Madhya Pradesh
Artist: Mayank Shyam

"Thin cats"
Art: Warli
Area: Maharashtra
Artist: Ramesh Hengadi

"Fat cats"
Art: Gond tribal
Area: Madhya Pradesh
Artist: Man Singh Vyam

"Saintly cats"
Art: Gond tribal
Area: Madhya Pradesh
Artist: Kalaba Shyam

"Brat cats"
Art: Gond tribal
Area: Madhya Pradesh
Artist: Man Singh Vyam

"Single cats"
Art: Patua scroll painting
Area: West Bengal
Artist: Swarna Chitrakar

"Paired cats"
Art: Gond tribal
Area: Madhya Pradesh
Artist: Durga Bai

"Bold cats"
Art: Sohrai
Area: Jharkhand
Artist: Putli Ganju

"Scared cats"
Art: Gond tribal
Area: Madhya Pradesh
Artist: Durga Bai

"Striped cats"
Art: Meena tribal
Area: Rajasthan
Artist: Unknown

"Cats with spots"
Art: Chitrakathi
Area: Maharashtra
Artist: Eknath Gangavana

"Dazed cats"
Art: Gond tribal
Area: Madhya Pradesh
Artist: Anand Shyam

"Cats with thoughts"
Art: Patua
Area: West Bengal
Artist: Moyna and Joydeb
Chitrakar

"I like cats"
Art: Gond tribal
Area: Madhya Pradesh
Artist: Roshani Vyam

I Like Cats

Book design: Rathna Ramanathan, minus9 design
Cover design: Avinash Veeraraghavan
Production: C Arumugam

Printed and bound in India by AMM Screens

ISBN: 978-81-906756-1-1

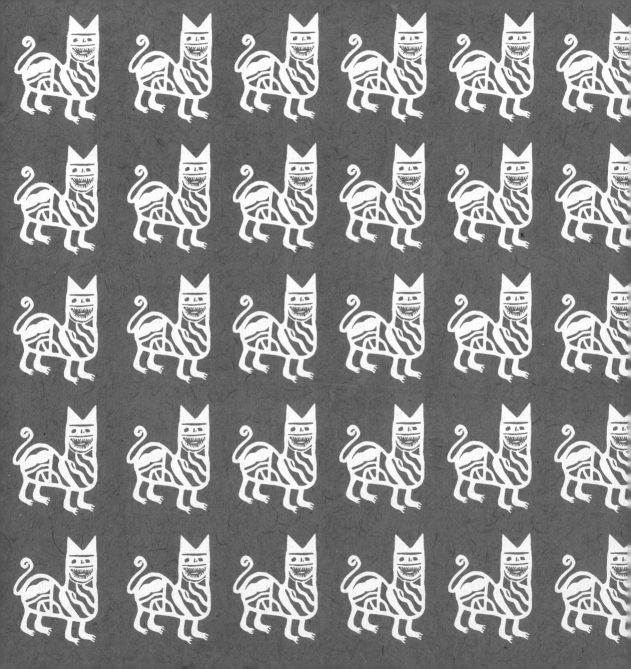

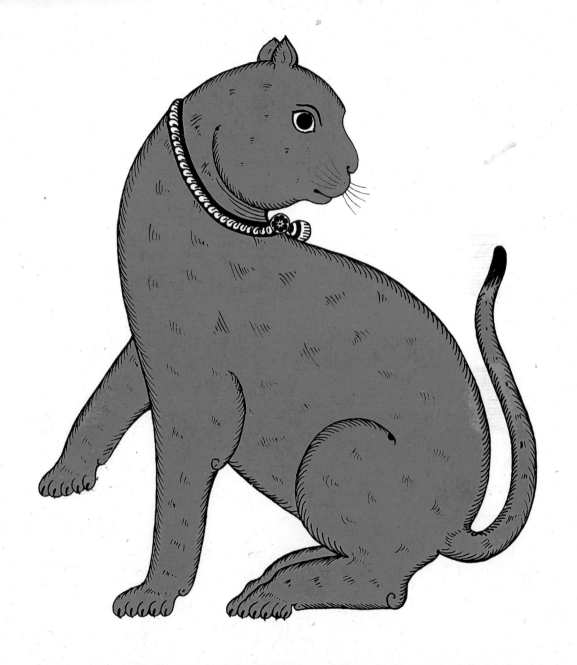